Cover GEORGES BRAQUE Still Life with Sonata 1920

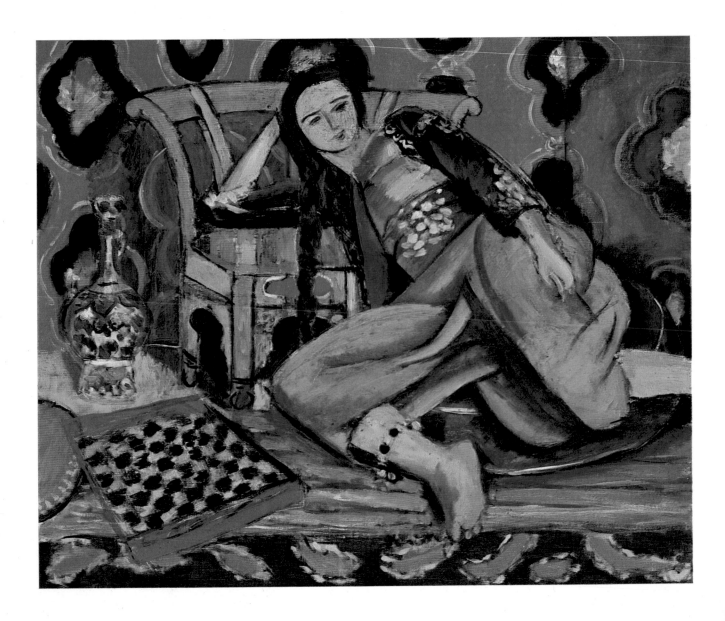

Paintings from Paris

Early 20th century paintings and sculptures
from the Musée d'Art Moderne de la Ville de Paris

Arts Council of Great Britain 1978

Oxford, Museum of Modern Art 2 July-13 August 1978
Norwich, Castle Museum 19 August-1 October 1978
Manchester, Whitworth Art Gallery 7 October-11 November 1978
Coventry, Herbert Art Gallery & Museum 18 November-31 December 1978

© Arts Council of Great Britain 1978
ISBN 0 7287 0179 0
Photographs of exhibited works by
Bulloz, Paris
Designed by Roger Huggett/Sinc
Printed in England by Shenval Press

A list of Arts Council publications including
all exhibition catalogues in print,
can be obtained from the Publications
Department, Arts Council of Great Britain,
105 Piccadilly, London W1V 0AU

Preface

It is obviously apt that the poster announcing this exhibition from the collections of the Musée d'Art Moderne de la Ville de Paris should reproduce one of Robert Delaunay's paintings of the Eiffel Tower. It was for Delaunay, as it has been for many, an obsessive image of Paris and a symbol of all that was modern. But it is also appropriate that it should be a painting from the most recent major donation to the museum, that of Mademoiselle Germaine Henry and Dr Robert Thomas, for much of the character of the museum's collections has been created by the important gifts and bequests from which, over the years, it has benefited.

In one exhibition we have rarely been so indebted to a single museum. On numerous occasions the Musée d'Art Moderne de la Ville de Paris has generously lent to our exhibitions. Now for six months we are able to borrow an entire exhibition, including many of its prime works, which allows us to go far in tracing the early development of modern art in France. For this unique opportunity we thank most sincerely Monsieur Jacques Lassaigne, director of the museum, and his colleagues who responded with great enthusiasm to our request to mount this exhibition. A foreword by Monsieur Lassaigne follows this preface and he later offers a tribute to Marcel Gromaire whose work is strongly represented in the museum's collections and to whom a special section of this exhibition is devoted. Mademoiselle Bernardette Contensou and Madame Andrée Abdul-Hak have given immense help throughout the preparation of the exhibition and this catalogue. We also express our warm thanks to Mademoiselle Henry and Dr Thomas for agreeing that many works from their donation might be included.

Joanna Drew
Director of Art

Michael Harrison
Exhibition Organiser

Foreword

We are especially happy to send, with the help of the Arts Council, a number of pictures chosen from the collection in our museum to be exhibited in several large cities in England. The works selected were painted in the first quarter of this century by artists who have become famous or by some of their contemporaries who are no less interesting. Thus the exhibition will give visitors some idea of the way in which the great periods of Fauvism, Cubism and the School of Paris are illustrated in our museum. The Fauvist movement, in particular, is illustrated by an exceptional group of pictures which have recently entered the museum through the gift of Mademoiselle Germaine Henry and Dr Thomas. Two artists, namely Rouault and Gromaire, are represented in this selection by outstanding works coming from the famous collection of Dr Girardin who was a great patron of the City of Paris.

In this way the selection which has been made corresponds to the character itself of the Musée d'Art Moderne de la Ville de Paris, I would even say, to its vocation. As a municipal institution, the museum has not wanted to form an objective presentation of modern art in all its complexity as the national museum has done. Rather, it has tried to play a complementary role by conserving what was forgotten or little known, and by giving stress to essential areas. It has been encouraged in this path by the generosity of some great benefactors. The collections of each benefactor have been respected and the presentation in the museum reflects the particular tastes of each one who helped towards its formation.

I hope that our visitors will find in the works which we have brought together – some of which are amongst the most precious and rare pictures (such as the Modigliani) – the opportunity of establishing with them personal links of friendship and understanding.

Jacques Lassaigne
Director of the Musée d'Art Moderne de la Ville de Paris

Introduction

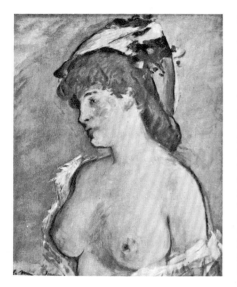

EDOUARD MANET
Blonde with Bare Breasts *c*1875
Musée du Jeu de Paume, Paris
(not in exhibition)

In Paris, at the Musée du Jeu de Paume, there is a painting by Manet of a young blonde woman. Her far-away gaze and the soft fullness of her shoulders and breasts are very different from the bold stare and harsh angularity of *Olympia,* the picture with which Manet had accosted the Parisian public ten years earlier. As her bare flesh is caressed by the warm air and sunlight, so it is described by feathery wisps of paint. The substance of the figure is that of the atmosphere surrounding her, the atmosphere between her and the eyes of the painter. Yet in her hat she wears a cluster of flowers whose red, green and black are solid pigments set firmly on the surface of the picture. We are suddenly jolted from luxuriating in the sensual ambience of what is being depicted and reminded that we are looking at paint on canvas.

Manet's picture was painted in 1875. The remaining quarter of the 19th century contained the mature work of Cézanne, the entire careers of Seurat and van Gogh, and, but for a few years, that of Gauguin – Post-Impressionism and the counter, or complementary, Symbolist movement. In different ways the elements of painting, in particular colour and line, took on an independence and life of their own, free from merely describing the subject of the picture. And while subject-matter was not neglected – no subjects were more deliberately chosen than Cézanne's Mont Sainte-Victoire or Seurat's Parisian suburbs – there was proportionately, after Courbet's paintings of fruit and Manet's celebrated single stick of asparagus, an increasing preoccupation amongst artists with the actual process of picture-making.

Matisse saw the starting point of Fauvism, the first great movement of twentieth-century painting, as "the courage to return to the purity of means", and French painters spoke increasingly about "pure painting". Very few, however, went on to adopt a purely abstract art without reference to an outside, physical reality.

For some explanation one might for a moment imagine Cézanne painting one of his landscapes. The tree trunk on the left which spans the picture from bottom to top is vertical, both in reality and in the picture as it is painted on the easel and eventually seen hung on the wall. The fields beyond receded from the artist more or less horizontally, but in the picture, however far away they might be, they had to be drawn up through 90° or thereabouts to exist on the same plane as the tree trunk. The problem is an old one but never before had its resolution been so deliberate or dynamic.

Abstraction was to be developed in Holland, Russia and Germany, but for the modern French painter the rich and complex implications of 19th century French art needed to be digested – anything but the briefest flirtation with the abstract was inconceivable.

And because of this inheritance the position of Paris as art capital of the world was undisputed. Ambitious young artists from elsewhere in France, Europe or even America would come to Paris to work in its art schools, to see paintings of its famous artists in the galleries and salons, and perhaps to rub shoulders with them in the cafés of Montmartre.

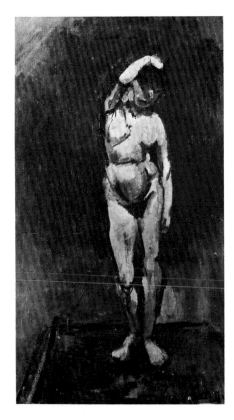

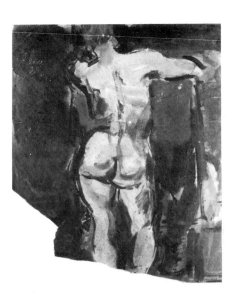

a suburb on the Seine, and, the following year, Derain introduced Matisse to Vlaminck, aptly enough, at the van Gogh exhibition held at the Bernheim-Jeune Gallery.

It was at about this time, or a little before, that Matisse painted *The Model* (cat. 46). There are a number of such paintings which superficially have the character of art school exercises. In fact they are, very evidently, the accomplished paintings of an artist already turned thirty. Apart from the cursory indication of a platform on which the model stands there is little attempt to define the space. The background is of dark blue-green, so dark towards the top that the model's hair is barely distinguished. Within and around the figure, lines of this blue-green, together with a rich brown, sharply reassert its drawing and these hues are broadened and diluted as shadows to the flesh tones. There is a cramped tension between the foreshortened, raised arm bent around the inclined head and the shape which results on the canvas, its angle echoed in the top left corner. The pose is awkward and Matisse has met it straight on, not attempting to give grace to the figure and making little concession to anatomical coherence.

The watercolours and gouaches of Rouault are more loosely executed but share a similar severity not least because of the same all-pervasive green-blue tonalities. The *Nude from the Back* of *c*1906 (cat. 62), an oil painting on paper, is worth comparing with Matisse's earlier picture. The weight of the figure is on the left leg. The left shoulder is dropped, the right lifted and the back is thus curved. The arms are raised onto an undefined brown support. The figure is built up from thin washes to dry opaque brushstrokes whose vigour is matched by their pink, red, brick and

Matisse had begun to study painting at the private Académie Julian in Paris in 1891. In 1893 he transferred to the remarkably liberal studio of the Symbolist Gustave Moreau in the Ecole des Beaux-Arts where Rouault was already a student and where he was later to be joined by Marquet and Manguin. Here was the first grouping of artists who were to become the Fauves, or "wild beasts", of the 1905 Salon d'Automne. Matisse met Derain when he later joined another studio. In 1900 Derain met Vlaminck; they shared a studio at Chatou,

ultramarine pigment. As in the Matisse, the left side is bounded by a dark sweeping outline, here broken at the waist. The right arm is only prevented from dissolving into mere patches of pink and turquoise by two rapid dark hieroglyphs.

The severity of the *Nude with Red Garters* (cat. 63) belongs equally to its treatment and its subject. The naked prostitute sits on the bed, her surroundings distinguished in the general blue wash by the most summary dark blue lines. Turning away from the light, her face is harshly delineated in dark blue, her eyes barely visible. But her body, its yellow and pink tones veiled in blue wash, faces the viewer full-square, her hands raised to tie back her hair, her stockinged and red-gartered legs apart. The stockings and hair are of dark blue strengthened in its density by traces of orange. Multiple outlines lash around the arms and face, repositioning them on the

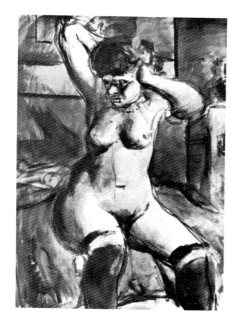

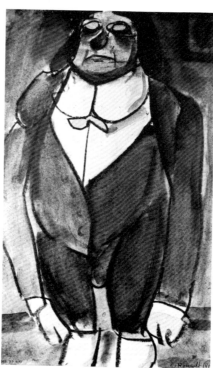

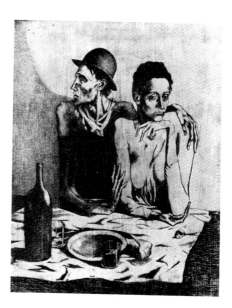

paper but also suggesting the intensity and movement of a moment quickly caught.

Rouault had undoubtedly learned much about the properties of blue both from Cézanne and the Symbolists. It is the most atmospheric of colours and in the transparent medium of watercolour, Rouault fully exploited its visual and emotive range. At its deepest it is the blue of night but it also gives the darkness of the hair and perhaps the actual colour of the stockings. It is the space and air of the room and, in an almost monochrome watercolour where it serves as tone and outline to the forms, it has an abstract quality belonging more to the picture itself than to the scene it describes. Rouault has finally added accents of opaque pastel,

some of blue but others of orange and, most prominently, red – the lower lip, the cheek, the nose, the nipples and garters – like a clown's make-up hovering between levels of reality.

During the following years Rouault developed an economy of means which, in the *Personnages,* was turned to bitter satire. The ignorant hypocrisy of the lackey (cat. 69), crammed into the picture frame as he is into his ridiculous clothes, is expressed in the crude yet direct heavy outlines of a child's drawing. He is as banal as the drawing would at first seem to be.

Picasso at this time was quite detached from the mainstream of French art. He had first come to Paris in 1900 and, after return visits to Barcelona, finally settled in a studio known as "Le Bateau-Lavoir" on the Butte de Montmartre. His friends during the early years were mainly fellow Spaniards and he took no part in Fauvism. *The Frugal Meal* (cat. 56), only his second etching, came towards the end of his "blue period". The elongated arms and hands are more influenced by El Greco than by anything more recent.

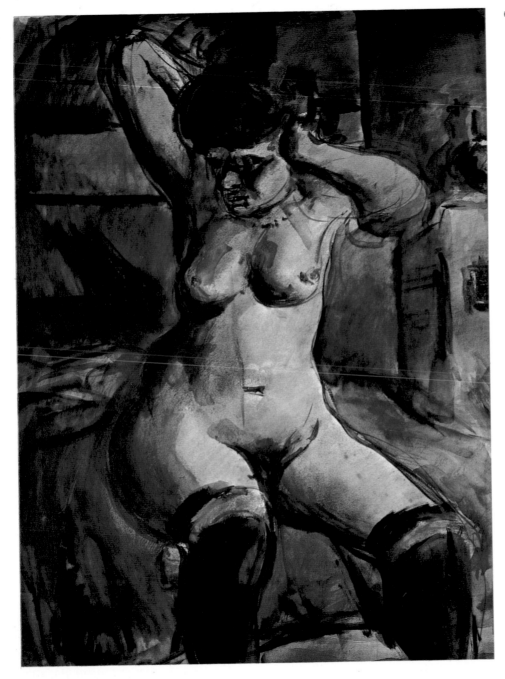

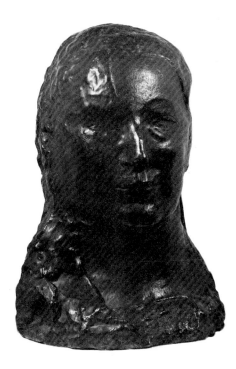

Rouault had, in 1903, become curator of the museum devoted to his former teacher Gustave Moreau. He had not maintained contact with Matisse and, though in 1905 he was to be bracketed with the Fauves, he was never to participate in that movement.

Soon after introducing Matisse to Vlaminck, Derain had been conscripted and remained in the army for three years. But in 1901 he wrote to Vlaminck:

"We are about to embark on a new phase, without partaking of the abstraction apparent in van Gogh's canvases, abstraction which I don't dispute. I believe that lines and colours are intimately related and enjoy a parallel existence from the start, and allow us to embark on a great independent and unbounded existence ... Thus we may find a field, not novel, but more real, and above all, simple in its synthesis."

The formation of the Fauve group was a gradual and piecemeal gathering around the older and dominant figure of Matisse. There were none of the manifestoes and theoretical writings which marked most later movements. It was rather a matter of increasingly exhibiting together and of painting holidays shared, two or three artists at a time, a habit inherited from the Impressionists. In the spring of 1901 Matisse and Marquet exhibited for the first time at the Salon des Indépendants. Next year they were joined there by fellow ex-Moreau students, Puy and Manguin, and in 1903 by Dufy and Friesz who had both come from Le Havre in 1900. The Salon d'Automne was founded in 1903 by, amongst others, Matisse, Rouault, Marquet and the Symbolist Odilon Redon: the first exhibition included a large retrospective of Gauguin. In 1904 the

Dutchman Van Dongen first showed at the Indépendants; Matisse, Marquet, Manguin, Camoin and Puy all showed together and often shared a model at Manguin's studio. That year Matisse formed a friendship with Paul Signac and they passed the summer together at Saint-Tropez. For Matisse the result of this direct contact with the colour theories of Neo-Impressionism was a picture of an idyllic sunlit bathing scene *Luxe, Calme et Volupté* painted with separate strokes of pure and brilliant colour. Matisse later wrote:

"... what characterised Fauvism was that we rejected imitative colours, and that with pure colours we obtained stronger reactions – more striking simultaneous reactions; and there was also the *luminosity* of our colours ..."

The painting was shown at the Salon des Indépendants in 1905 at what was, with Matisse as president of the hanging committee, the first full group exhibition of the Fauves. Its effect was described by Dufy:

"I understood the new *raison d'être* of painting, and impressionist realism lost its charm for me as I beheld this miracle

The modelled head is that of his mistress Fernande Olivier (cat. 57). The chin, lips, nose and the right side are firmly modelled. On the left side, however, there is only real definition of form from the upper-cheek down to the mouth. The side of the face dissolves into, or emerges from, the rough modelling of the hair, and the eye is described merely by an incised line in an almost unmodelled area. It is as though, having carefully modelled one side, Picasso thought it irrelevant to give equal definition to the other but, very potently, it points to the piece of sculpture being just that, a fabrication with an independent reality of its own.

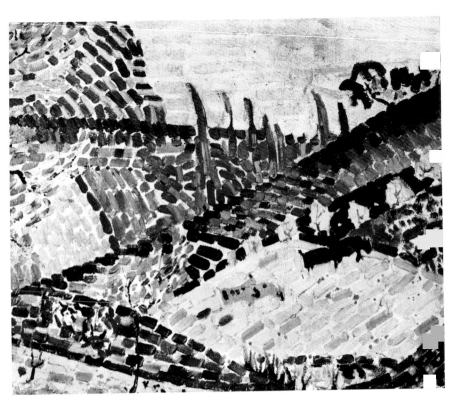

of the creative imagination at play, in colour and drawing."

It was in the light of the South that most Fauves developed their use of heightened colour. Camoin, Puy and Manguin spent that summer in Saint-Tropez. Matisse and Derain went to Collioure. Influenced by Matisse, Derain had begun to experiment with the colour divisionism of Neo-Impressionism but here rejected it: "it ignores things that owe their expression to deliberate disharmonies." Instead, in *The Lighthouse at Collioure* (cat. 9) he used individual broad strokes of colour separated for the most part by bare canvas though significantly not in the blue areas.

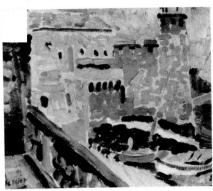

He wrote to Vlaminck of a new conception of light in which shadows are negated by their luminosity. Light was to be modelled by hue and not by tone.

But for both Matisse and Derain this summer and indeed the entire Fauvist period was a time of unsettled and anxious experiment. Even in Collioure Derain saw that "up to now we have only dealt with colouring. There is a parallel problem in draughtsmanship." Very much influenced by Gauguin the two artists began to work with broader, flatter areas of colour, pulling the space of the landscape up to the picture surface.

Robert Delaunay's landscape of the following year (cat. 6) adopts Derain's individual brushstrokes though in a more systematic way. All trace of descriptive colour has gone.

17 OTHON FRIESZ Autumn at Honfleur 1906

3 GEORGES BRAQUE
The Olive Tree near to L'Estaque 1906

HENRI MATISSE Le Bonheur de Vivre 1906
Barnes Foundation, USA
(not in exhibition)

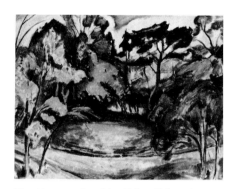

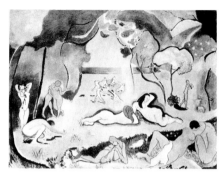

Friesz had passed the summer of 1906 in Antwerp with the youngest of the artists from Le Havre, Georges Braque, who was making his first, and rather late, moves towards a Fauvist style. That autumn the combined experience of seeing the Fauves at the Salon d'Automne and travelling south to L'Estaque heightened the colours of his palette. In *The Olive Tree near to L'Estaque* (cat. 3), the tree and the building, set as they might be in a painting by Cézanne, are drawn in a blue which runs throughout the picture, heightening the warm hues. Rippling strokes of intense viridian, red and orange are overlaid on paler tones in various combinations of contrast and harmony.

The picture painted by Othon Friesz at Honfleur on the Channel coast (cat. 17) is handled very differently. It heightens and elaborates on autumn hues rather than replacing them by invented colour. Strong linear rhythms run through the branches and foliage. Dryish paint is applied quite thinly, more scumbled than in separate strokes. Intense oranges are contained between viridian on the right and yellow and dull mauves on the left. It is the setting for a *pastorale* without the figures which were to populate Friesz's later compositions.

By the autumn of 1907, only two years after a critic had coined the term "Fauves", Fauvism as a movement was ended. Matisse had followed *Luxe, Calme et Volupté* by *Bonheur de Vivre,* set in a Collioure landscape, yet an even more idyllic and timeless scene of pastoral calm. Increasingly he sought to replace the high-pitched dissonances and confused techniques of early Fauvism by harmonious order – "an art of balance, of purity and serenity . . . something like a good armchair." Derain, like Matisse, moved away from an art of spontaneous response. He had written in 1906 "I see myself in future painting compositions, because when I work from nature I am the slave of such stupid things." The landscapes which he brought back from Cassis in 1907 were drained of Fauvist colour, restricted to dark greens, browns and ochres. Friesz and Braque together at La Ciotat and briefly at L'Estaque had been painting landscapes with strong curvilinear rhythms and by the end of the summer their palette also was of a restricted range.

45 ALBERT MARQUET
Notre-Dame de Paris under Snow *c*1912

81 MAURICE DE VLAMINCK Forest *c*1910

78 KEES VAN DONGEN Two Women *c*1910

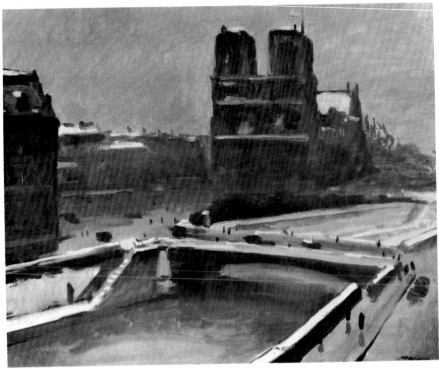

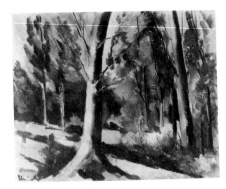

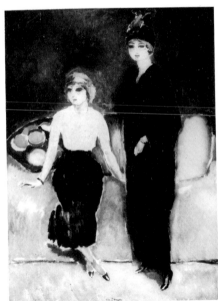

Having pushed colour to its utmost intensity Vlaminck subdued his palette and adopted a fairly loose Cézannesque landscape style (cat. 81). Van Dongen, who had been the "wildest" of all, produced in *c*1910 a painting of elegant charm and poise (cat. 78) and Marquet painted Notre-Dame (cat. 45) from nearly the same point as Matisse's earlier pictures, almost entirely in greys. Even the flag on the right-hand tower is indicated merely by a thicker brushstroke of a slightly lighter tone.

PABLO PICASSO
Les Demoiselles d'Avignon 1907
Museum of Modern Art, New York
(not in exhibition)

10 ANDRÉ DERAIN Bathers 1908

11 ANDRÉ DERAIN Still Life on a Table 1910

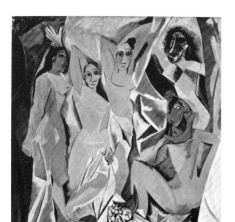

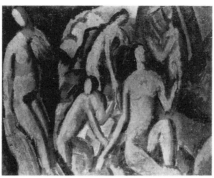

For artists seeking a way of bringing form into painting two major influences came into prominence at this time. On the one hand Cézanne's death in 1906 was followed in 1907 by an exhibition of his watercolours at Bernheim-Jeune's and a retrospective exhibition at the Salon d'Automne. On the other hand, primitive art began to suggest the possibility of a bold simplification of form, mediating between the description of reality and, what is inevitably, the artist's act of (artificial) construction. The precedent already existed in Gauguin, and Matisse, Vlaminck and Derain had been collecting primitive sculpture since 1905 or 1906.

In the autumn of 1907, Braque was introduced to Picasso. It was a crucial time for both artists. It seems that Picasso had only recently come to see the potential of African sculpture and had drastically altered the heads on the right of *Les Demoiselles d'Avignon,* a painting whose radical realisation of form in a tightly constricted space inspired Braque that

winter to paint his own *Great Nude.* The influence of Cézanne was to be more telling and lasting than that of African art. In the following year Braque and Picasso painted landscapes of massively simplified and angular forms experimenting with Cézanne's technique of *passage* which allowed one form to fuse into another or into space. Except for greens, browns and greys, colour was banished. Their concentration was on the resolution of three-dimensional form and space on a two-dimensional surface. From this point, until Picasso left Montmartre for Montparnasse in 1912, the painting of Picasso and Braque developed along remarkably close lines.

The recurrence of pictures of bathing groups in itself reflects the influence of Cézanne. Like *Les Demoiselles d'Avignon* Derain's five figures (cat. 10) pack the format of the painting. They are faceless and while not distorted like Picasso's nudes, their bodies and limbs are equivalent in colour and form to the trees which surround them. The shadow down the back of the right figure is directly equivalent to the tree trunk behind it.

Derain had come to know Picasso but his contribution to Cubism was to be peripheral and his still life of 1910 (cat. 11) with its raised table-top denying perspective and its jugs seen at once from the side and from above are basically Cézannesque.

Roger de la Fresnaye's *Still Life with Three Handles* (cat. 34) goes further even if it ends up being a tentative and rather forced exercise in Cubist construction. The perspective of the table is conventional and the objects of the still life, lit from the left, are set in a fairly unambiguous spatial relationship. But the glass is defined at its base by black lines, then rises to dissolve into the planes around, the curve of its rim displaced to the left. The two large handles are, rather unconvincingly, brushed into the background and the convexity of the central jug is modelled so as to hint at the concavity within. More strikingly, however, it is the abstract play of arabesques, of near symmetry and echoed forms which emphasises the two-dimensional portrayal of the still life.

One feels that La Fresnaye was probably more at ease in the small *Still Life with Lemons* (cat. 35) of the following year where brown is the ground colour of the painting, the colour of the basket to the right, the fruit to the left and the shadow of the lemon.

Picasso's *The Pigeon with Peas* (cat. 58) is of the same year. One's first reaction is to seek out recognisable elements – the peas, the claw and perhaps the upturned head of the pigeon, the base and rim of a container, to the right a glass (whose transparency is frequently exploited in these paintings), in the centre a candle flame. After that the "perhapses" increase. Objects and spaces begin to be defined but then dissolve or are denied. A line can be an edge or can shade off on one side into a plane or open space. It can exist in its own right as part of the grid which ties the picture to the surface, never allowing the shallow space to deepen. Paint varies from the thinnest atmospheric scumble to a textured impasto. At one point brown brushstrokes almost realise the physical existence of the handle of a wooden chopping board but against this there is the triangular sign of the candle flame where no attempt at illusion is made. Above, the word "CAFÉ" whose actual existence as a sign, painted on a surface, is no different to its presence in the picture. There is constant flux between solid objects and space, between two and three dimensions, between description and the mark made, between the various realities.

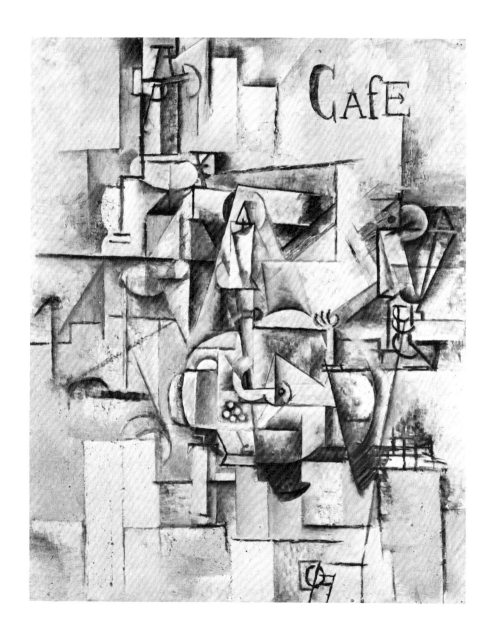

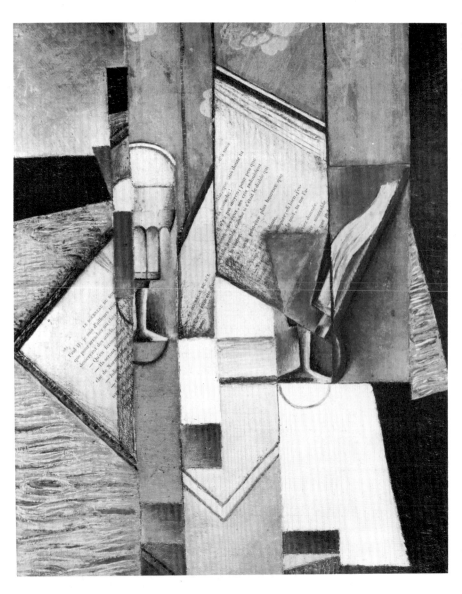

Juan Gris joined Picasso at the Bateau-Lavoir in 1906 before becoming an artist. He began seriously to paint only in 1911 when Cubism was already far advanced, but with the advantage of having closely watched Picasso's development. Picasso introduced collaged elements of reality in works of 1912. In *The Book* (cat. 19) Gris glued sections of two pages diagonally onto the canvas. They are split by vertical divisions, the top of the right page slipping down (and forward?); charcoal shading is added. The edges of the book and its binding are painted in but, where the bottom corner "should be", illusionism is replaced by parallel lines, echoed, or displaced downwards, in the column to the left. The white areas belong to the picture surface but the blue rectangles seem to have implications of sky before one of these intersects the book and right-hand glass. At the top this glass begins in flat silhouette and descends through an illusionistic stem to a base indicated by a line. Scraped paint simulates a wooden table surface and vies with the reality of the printed pages.

Before looking at the other contributors to Cubism we might go forward to 1920, beyond the war which had interrupted, and nearly ended, Braque's career. Braque's painting had always been gentler in character than Picasso's but now the possibilities which had been opened up by Cubism were used with a new calm and mysterious lyricism (cat. 4, see cover). The most strident notes are the black and green marbling and the clarinet with its holes and hard edges. Broken in two, its combed brown paint is taken up in a thin triangle on the left edge so that it should not merely belong to the clarinet but also to the picture. Its parallel combing is echoed in

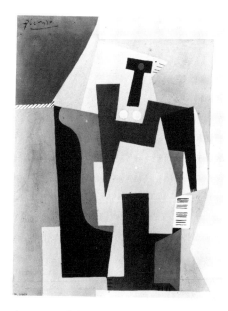

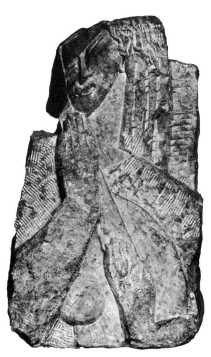

plane. Strands of hair fall from the top plane onto the front.

The Lipchitz is a more assertive being. The head is split into interlocking blocks, one eye protruding, the other indented. The curves are tight and each plane is clean-cut. No distinction is made between the figure and the block on which it sits or the fat clarinet held in a hand carved in negative. One thinks of the Zadkine as "she" but of the Lipchitz as "it" – they inhabit entirely different worlds.

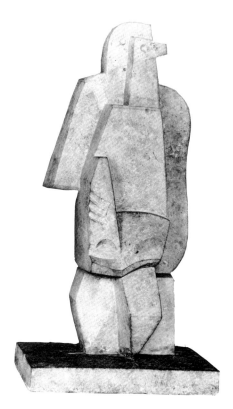

the staves of the sonata. The dull green of the fruit recurs in a pattern with the grey which pervades the entire picture and out of which objects emerge, floating and almost cloudlike in form. Behind the glass, the thinnest veil of white paint indicates what might be a bottle.

Three years on, Picasso's small composition of 1923 (cat. 59) shows in what different directions the two major figures of Cubism had travelled. A figure is indicated: one brown eye in a black T, two white discs for breasts, a third for the navel, hair and toes marked by black lines. In place of the flux between realities, Picasso's figure belongs unambiguously and aggressively to the flat jagged areas of colour.

In parenthesis, there is perhaps a similar contrast to be drawn between the Zadkine sculpture of 1918-20 (cat. 82) and the Lipchitz of 1920 (cat. 41). The Zadkine is a block of stone with a front, two sides, a back, a top and a base. The back and the greater part of the sides are barely carved, only into roughly cuboid blocks. The half-length figure is carved on the front of the block but from the point of the nose and the cheekbones the face turns into the side

The early development of Cubism was almost exclusively the result of the close co-operation between Braque and Picasso. They were oddly remote figures. Picasso never participated in the large salons or group exhibitions and, after 1909, Braque followed suit. Moreover, they stood apart from the discussions and theorising which characterised Cubism as a group movement. Gleizes, who only met Picasso in 1911 and possibly never met Braque, wrote of the café meetings and the Monday evening gatherings which took place at his studio in Courbevoie from 1910: "the necessity of forming a group, of frequenting each other, of exchanging ideas, seemed imperative." The chief links with Picasso were through Metzinger and Apollinaire who often visited the Bateau-Lavoir. They showed as a group in 1911 at the Indépendants and the Salon d'Automne where Le Fauconnier, Léger, Delaunay, Metzinger and Gleizes hung in one room with Lhote, La Fresnaye and Segonzac in the next. The brothers Marcel Duchamp and Jacques Villon also exhibited in the Cubist room and their studio at Puteaux soon became another meeting place out of which came the first Section d'Or exhibition in 1912 planned by Villon, Metzinger and Gleizes to show the successive stages of Cubism.

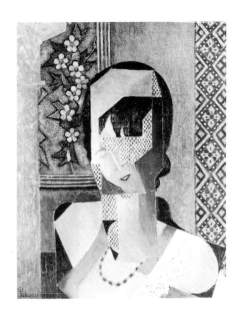

The theorists of a movement tend to be the more academic in their own painting. In 1912 Metzinger and Gleizes had written their book *Du Cubisme,* the most influential of all contemporary writings on Cubism. Metzinger's *Woman with Lace* (cat. 49) is one step on from the introduction of collage where collage itself is parodied in paint.

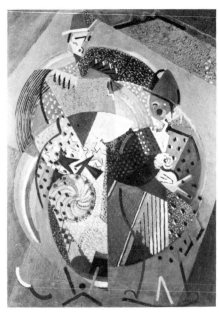

Several Cubist artists sought a more dynamic construction to their paintings and veered away from the standard Cubist still life constructed on a grid. We shall meet the theories of "simultaneity" in Delaunay and Léger: the term was coined by the Italian Futurists and much discussed at the Courbevoie and Puteaux meetings. In his painting of 1917 (cat. 18) Gleizes has spliced the identity of clowns in all their motley onto intersecting and seemingly revolving discs. The discs are packed with contrasting areas of stripes, stars, tachist brushstrokes and textured paint. Such were the freedoms which Cubism had won.

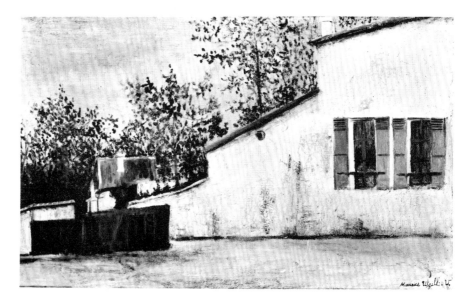

What had happened, and happened very quickly, was an entire opening up of the relationship between the picture and its subject. The Impressionists had shown that the way in which we see things is not constant but is dependent upon conditions of light and atmosphere. Hence Monet, in the 1890s, had painted quite different pictures of the same haystacks or of the façade of Rouen Cathedral seen from the same point. Since then it had been increasingly realised, and not merely by painters, that what we take to be reality is also subject to our own faculties of perception and consciousness. Indeed, these faculties are a part of reality. In his *La Tendance de la Peinture Contemporaine* Olivier-Hourcade went back to quote Schopenhauer:

> "Kant's great service was to distinguish between the appearance of a thing and the thing itself, and he showed that one's intelligence stands between the thing and us".

Early in the twentieth century Henri Bergson tried to define the nature of our consciousness as, in fact, creating reality through a continual flux of passing and deliberate thoughts, sensations and memories.

It is likely that few Cubist painters read much of Bergson and Kant but it remains significant that their circle included poets and writers who probably did. In terms of painting Cubism had finally put an end to the notion of a picture being a mere vehicle for an illusion of reality. Instead it embodied many interwoven levels of reality and actively participated in reality itself. Picasso's *The Pigeon with Peas* or Braque's *Still life with Sonata*, reflect, as we look at them, the complex and, importantly, not wholly rational workings of our consciousness.

While Cubism was the dominant force in Paris during the pre-war years there were a number of artists whose careers were largely independent of major movements. Chagall, Modigliani, Soutine and Pascin were Jewish immigrants: Chagall and Soutine from Russia, Pascin from Bulgaria, Modigliani from Italy. As such they did not belong to the French tradition. They deliberately moved into the artists' areas of Paris and there was contact with the Parisian *avant-garde,* but naturally they associated more with each other as fellow exiles. They used to meet at the Café du Dôme and, at one time, all but Pascin had studios in the same building, La Ruche, where Léger also worked. In this exhibition we meet their work after the war had ended.

Even more remote, though a Frenchman, was Maurice Utrillo who had been put to painting by his mother, Suzanne Valadon, in 1902 after his first internment as an alcoholic. His paintings (cat. 72, 73) are of the streets and buildings of Paris and especially Montmartre. His style was derived from Sisley and Pissarro, and in this pre-war period his palette was limited primarily to whites and greys. After the war he is portrayed by his mother (cat. 74) painting his townscapes not outside but in the studio, probably aided by picture postcards whose brash colour was to take over from the quietness of his earlier work.

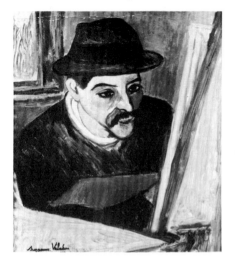

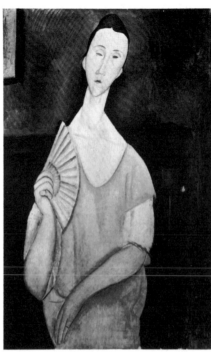

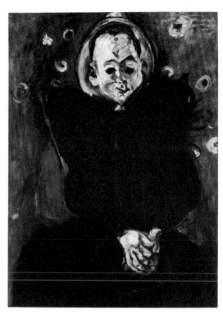

While Utrillo's work was confined to scenes of the environment he knew, his friend Modigliani painted only nudes and portraits. Arriving in Paris in 1906 he soon made contact with Picasso's circle, at that time still a grouping of exiles though with notable additions like the poets Apollinaire and Max Jacob. His essentially linear style was influenced partly by pre-Cubist Picasso, partly by Matisse, Lautrec and Rodin. African sculpture had a considerable effect on his simplification of form and in 1909, encouraged by Brancusi, he made sculptures which derived strongly from that source. He also saw that year Cézanne's painting of the *Young Man with Red Waistcoat* which confirmed for him the possibility of deforming the human body to his own ends, though concerned with human expression more than with the exploration of pictorial

form. The relaxed arm of the *Woman with a Fan* (cat. 51) is streamlined into a languid seal-like form, a languidity echoed in the fall of her dress, its neckline and colour. Against this are posed the drawn-up shoulders, the attenuated neck and head set at an angle, the pursed mouth, the tight features of nose, eyes, eyebrows and tied-back hair, and the vigorously brushed blood-red wall behind, darkened against the flesh of her neck.

Soutine's expression of humanity was more violent. The upper part of the woman (cat. 70) is like a vast and sinister butterfly at full-spread. The shoulders of the deep blue dress billow up and the clasped hands press tensely down into her lap. Within the deformed halo of her bonnet, her red hair is pulled back from the bulging forehead which shares the greens of the background, where flower-like motifs swirl without order. Her eyes are like dreadful cavities of the blue of her dress.

It is understandably around these painters that much of the mythology of the bohemian artist and of the Paris art-world itself has been founded. Like Utrillo, Modigliani was an alcoholic; he was also a drug addict and suffered from tuberculosis. Soutine had managed to curtail his drinking

53 JULES PASCIN Marcelle *c*1927

54 JULES PASCIN
Venus, Nude from the Back 1929

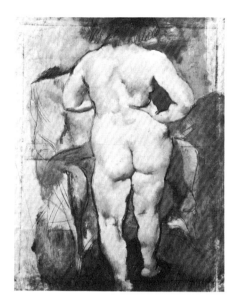

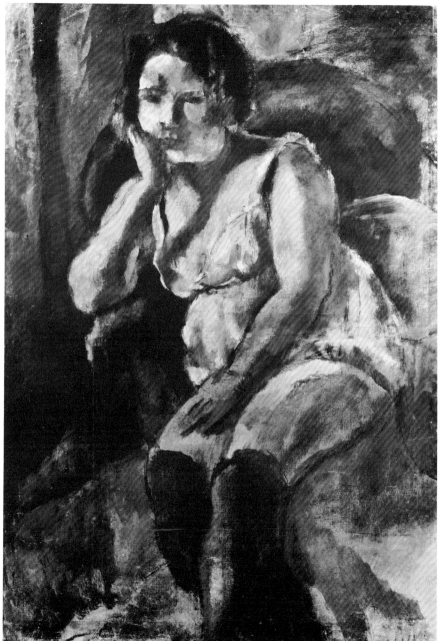

but suffered from stomach ulcers and was
afflicted by an obsessionally tragic and
despairing view of existence. The self-
destructive dissipation of Jules Pascin was
legendary. Each was rootless both socially
and in his art, and their painting was far
more concerned with their experience of
life than with the development of formal
means. (The same could be said of Picasso
in his first years away from Spain.)

Pascin's pictures are usually of wistful
prostitutes, nude or half-unclothed. In
effect they are drawings to which paint has
been sparingly added in transparent mists of
deceivingly pretty colour. *Marcelle* and the
Venus, Nude from the back (cat. 53 and 54) are
bulkier figures than most, and the *Venus,*
cut off at the top of her head and her heel,
and with its strong vermilion and
charcoal outlining, is more strident in

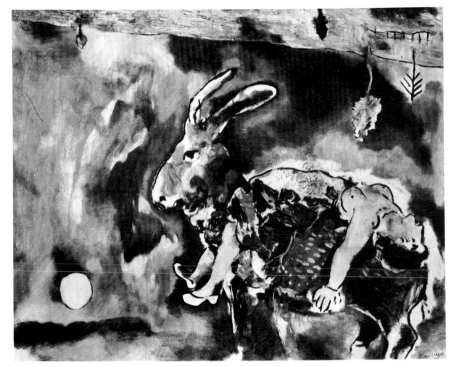

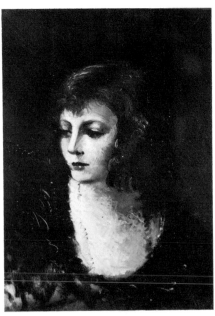

character. Marcelle's daydream is matched by the subdued range of chalky colours making patches of light and shadow in which forms are barely distinguished.

Chagall's roots in the Russian folk-lore which had pervaded his childhood were very deep. With Cubism, or more particularly Robert Delaunay's "Orphism", which we shall come to, he had the advantages of the outsider who can take what he sees to be useful to himself while not being involved in the movement as such. He experimented with the fragmentation of Orphism to bring together the images and memories which flowed in his mind. When he returned to Paris in 1923, after eight years back in Russia, such facetting was no longer needed and images could float and co-exist in an irrational world of their own making (cat. 5).

We can look briefly at some of the artists who had been Fauves. Dufy's painting had from early days possessed a free directness which, in the twenties, he now indulged in excited and playful cascades of brushwork (cat. 14 and 15). A wheel is a circular sweep, a tree trunk a single stroke of brown. Derain's portrait head (cat. 12) is in similar vein with lines scratched into the black dress and its necklace a zigzagging squiggle.

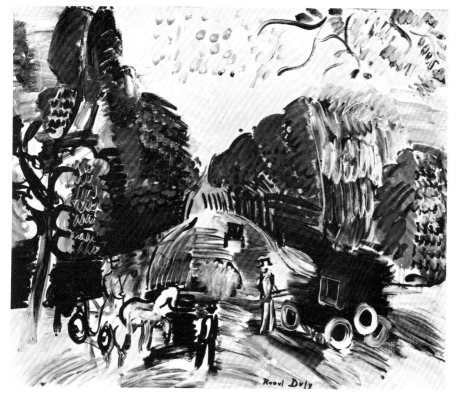

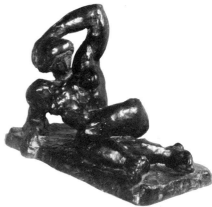

Matisse's art had continued to grow. The *Odalisque with Armchair* (cat. 48, see frontispiece) is a lush and masterly orchestration of line and colour. The figure, leaning on the chair, is as dramatic an arabesque as the sculpture of twenty-one years before (cat. 47), here set against the bold patterns of wall and floor coverings. Reds and pinks, blues and turquoises echo each other throughout the picture. The flowing lines of the odalisque are countered by the staccato pattern of the chequer-board, the tachist pink brushstrokes (light or pattern?) on the waistband and the beads of her anklet. The wall-pattern is interrupted and saved from monotony by a transparent curtain which simply transforms the black motifs into green.

7 ROBERT DELAUNAY
Nude at the Dressing-Table *or* The Reader
1915

ROBERT DELAUNAY The Eiffel Tower 1910
Oeffentliche Kunstsammlung, Basel
(not in exhibition)

The concept of simultaneity which we touched on with Gleizes was associated with the conviction of many artists that the scope offered by Fauvism and Cubism should in some way be applied to relating art to the fact of modern living. Amongst those who had exhibited in the Cubist room of the 1911 Salon d'Automne there were two artists, Robert Delaunay and Fernand Léger, who must have been in Apollinaire's mind when he wrote that:

"out of these two movements which follow upon each other and fuse so successfully, is born an art that is simple and noble, expressive and precise, passionate in its search for beauty, and ready to tackle those real subjects which yesterday's painters failed to undertake."

Delaunay would probably have accepted Apollinaire's description of his artistic origins: ". . . a slow and logical evolution from Impressionism, from Divisionism, from the works of the Fauves and from Cubism." All these movements had worked towards the fusion of objects with the space surrounding them. Certainly Delaunay acknowledged his debt to Cézanne through whose late watercolours he saw that the incidence of light on an object actually breaks and obscures its outlines, effectively destroying the object. It was in light that Delaunay found the only true reality, and he sought the expression of that reality, in what he called the "simultaneous contrast" of colours.

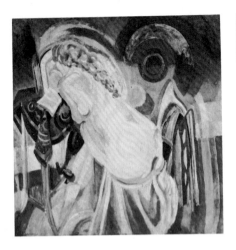

After a series of pictures which seemed to comprise facets of coloured light, he adopted the use of concentric rings of colour which avoided any implication of angled recession into space. Instead these discs sat on the surface of the picture and space was created solely by the contrast of their colours. He painted a number of abstract pictures but then, in paintings such as the *Nude at the Dressing-Table* (cat. 7), he attempted to fuse the discs with the specific reality of a scene. Significantly the most positive colours do not belong to the figure, the supposed subject of the picture, but to its surroundings.

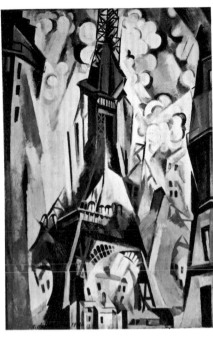

The painting of the Eiffel Tower in this exhibition (cat. 8) dates from 1924-6. Delaunay's first Eiffel Tower pictures were painted in 1909-11 and it is worth quoting the poet Blaise Cendrars who visited the tower with Delaunay in c1912 for his description is relevant to much painting of the time.

"None of the known techniques of art can claim to have solved the pictorial problem of the Eiffel Tower. Realism diminishes it, the ancient laws of Italian perspective attenuate it. When we moved away from it, it dominated Paris, stiff and perpendicular; when we approached it, it tilted and leaned over us. Seen from the first platform it spiralled upward; seen from the top, it sank into itself with

straggling legs and indrawn neck.
Delaunay wanted to show Paris
simultaneously, to incorporate the
Tower into its surroundings . . .
". . . He succeeded at last with the
magnificent picture we all know. He cut
it open at the joints in order to fit it into
the frame; he foreshortened and tilted
it in order to let it have its full dizzy
seven hundred feet; he grasped it from
different angles, in fifteen different
perspectives – one part is seen from
below, another from above; the houses
surrounding it have been taken from the
right, from the left, in bird's eye view
and seen from the ground up . . .".

The 1924-6 painting is taken from a single
aerial view looking down onto the gardens
beyond. Here the tensions, which at the
beginning of this essay we observed in
Cézanne, between the elements of the scene
being painted, and between those elements
and the picture surface, are at their most
tantalising and dynamic. Spanning the
picture, the tower is truncated by all four
edges. Its cross girders run parallel to the
paths beneath but its sweeping curved faces
set up an ungraspable magnetism with the
ground behind and the picture surface (in
front?). At the bottom are elements which
might equally belong to the tower or to the
gardens. At the top right the tower is
edged by the same green as the grass below.
The tower seems poised to fall, held only
by the forces across the canvas and the
thrusts within itself.

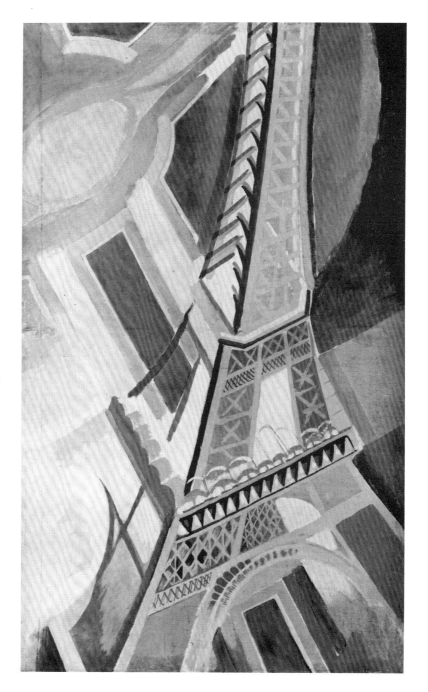

As Matisse and Picasso had found in African art the possibility of constructing reality rather than making an illusion of it, Fernand Léger wrote in 1924:

"The mistake [of the sixteenth century and of much art which followed] is to *imitate*, to copy the subject slavishly in contrast to the preceding period known as Primitive, which is great and immortal because it invented forms and means."

Like Delaunay, Léger had a brief period of painting abstract pictures but after war service – "three years without touching a brush, but in contact with crude reality at its most violent" – he saw the way ahead to painting based on mechanical forms, expressing the beauty which is everywhere, "in the arrangement of saucepans on the white wall of your kitchen, perhaps more there than in your eighteenth-century salon or in official museums."

The *Man with a Pipe* (cat. 38) portrays modern man in his urban and mechanical environment. There are hints of a staircase and the dog inhabits a space of its own, but no consistent light source unites the picture, and the scaffold is largely a formal one whose blacks and whites owe much to the abstract painting of Mondrian. The man is not distorted into modernity but is constructed of elements like those which surround him.

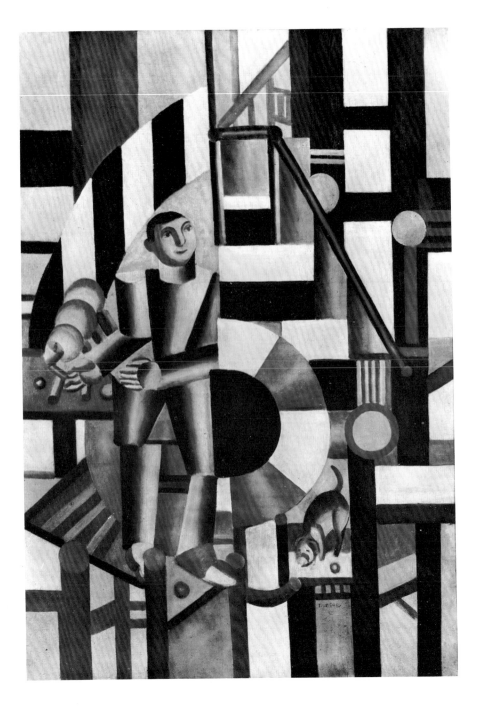

It was inevitable that in a period when the order of outside reality was fragmented, a new order should be sought. Juan Gris, the most intellectual of the Cubist painters, introduced geometry into his paintings and the choice of the title Section d'Or reflected the mathematical leanings of the Villon brothers. After the war, Ozenfant and Jeanneret (better known as the architect Le Corbusier) published their *Après le Cubisme,* later elaborating their ideas in *Le Purisme.* Their theory was that the modern age of science and technology should be met with an art of classical order, clarity and objectivity. They adopted the still life subject-matter of Cubism but, instead of fragmenting or distorting an object to show its different facets, they attempted to portray, in true Platonic manner, its ideal and essential form. Thus Ozenfant's violin (cat. 52), seen both in plan and elevation, has the quality of an emblem: it is more the idea of a violin than the actual object. Such paintings have a strangely dreamlike quality and it is perhaps not too incongruous that Léger was attracted both to Purism and to Surrealism – the one professing objectivity while the other explored the irrational workings of the subconscious. Both movements were in search of archetypes.

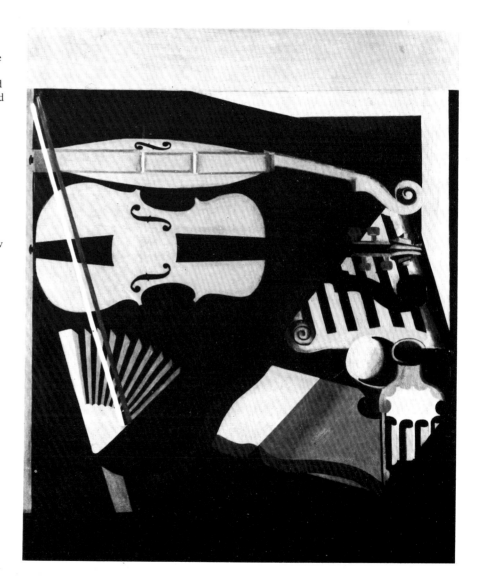

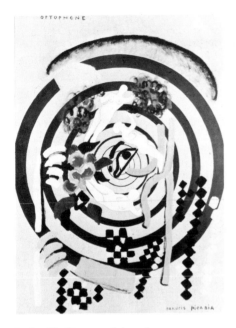

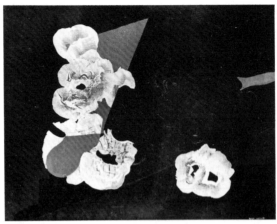

In fact Picabia, one of the prime movers of Dada and Surrealism, had been involved in Cubism from 1909 and was a founder member of the Section d'Or. Whereas we have talked of paintings by Picasso and Braque facing us with our own consciousness, Picabia's *Optophone II* (cat. 55) deftly liberates the innovations of Cubism to relate to each other as elements of our subconscious. Nor are the flowers of Max Ernst's painting (cat. 16) the real flowers of a still life. As paint applied and scraped off they are like the ghosts of flowers floating in a primeval darkness.

Ernst had come to Paris in 1922 and Paris became one of the centres of Surrealism, but only one of several throughout Europe, and during the twenties its dominance was coming to an end. There remained French artists, not least Braque and Matisse, who were yet to produce some of this century's greatest art, and there were French Surrealists including the notable figures of Duchamp, Picabia and André Masson. But it was as if Paris had in pre-war years been a channel through which modern art had needed to pass, and now art widened out geographically in all its variety until the Nazi threat caused another channelling and New York took over the rôle which Paris had vacated.

Michael Harrison

Homage to Gromaire (1892-1971)

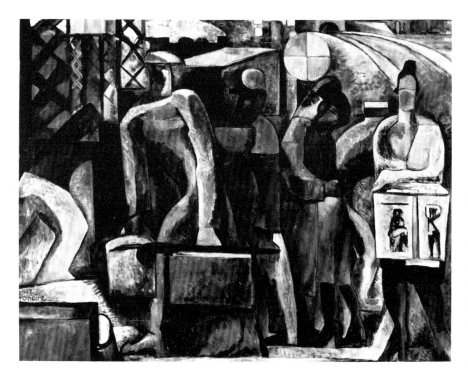

The paintings by Gromaire which are exhibited here come almost entirely from the magnificent collection of works by this painter gathered year after year by Dr Girardin and which he donated to our museum with the whole of his collection. These works, more than a hundred in all, covering all the essential moments of the artist's creative career, will constitute the basis of the large retrospective exhibition of Gromaire which our museum is preparing for 1979-80. No doubt this exhibition will allow us to measure the full range and scope of the work of this artist who, seven years after his death, still remains barely known.

In his lifetime, the slightly severe dignity of his character, the assertion of ideas and opinions to which he remained faithful without any concession, would ward off superficial minds and flatterers. He was concerned only with the community of artistic creation, to help and advise the young who gathered around him. He was aware of what he brought to men, to his brothers. "I believe," he wrote, "that a picture is above all a gift from the heart, a transfer of living forces." These living forces he had acquired in solitude, "the necessary means to the accumulation of energy." Thus, the solitary one "can feel the swelling tide of the world against his four walls, walls of glass through which he can perceive the immense suffering." He believed in painting as an irreplaceable instrument, and had forged an admirable technique, always sensitive, emotional, alive.

"I owe my colour to my native country, which has never ceased to charm me. It was imposed upon me from childhood, dictated somehow by experience." A man from the north like Matisse, inspired by the

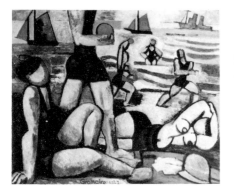

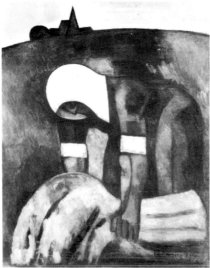

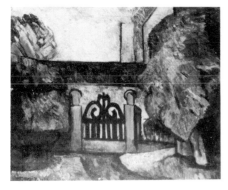

nuances of the skies above the Flemish plain, his palette is one of the most beautiful of modern French painting, based on powerful ochres, browns, blues and greens to which he adds the splendour of jewels, pearls, sapphires, rubies, agates and emeralds. His colours, juxtaposed, harmonized, heightening one another, remain pure and uncompromising. Nothing is more opposed to the pictorial recipe, to the mere adjustment to the particular subject, to complacency. His drawing is no less personal. Acute, decisive, it provides not only a basis, an architecture for the composition; in the construction of the human body as in the elements of country or urban landscape, it rediscovers references to geometry. It is a framework open to the outside world, an active structure which can be enriched in many ways.

Gromaire had carried this knowledge of colour and drawing so far that he wanted to share it with all those who thronged to his lessons at the École des Arts Décoratifs. He will remain an unforgettable teacher, one of those who proved that the teaching of art could only be done through ever-renewed disciplines enriched by the discoveries of the greatest modern artists.

Gromaire also believed in painting as an incomparable means of expression. Through these means, he wanted to speak of life, of the visions that had filled his eyes, of his understanding of man, of his toils and his pains, of his deepest needs. Like Léger, at about the same time, he was a visionary of present times, of dramas gone through, of the collective life of "the anxious, labouring people who sense the return to chaos." No-one better than he has conveyed the majesty, the truth, the fullness, the dignity of working people – in particular of those working in the fields or in the forest. And if sometimes human types attracted his emotional or even satirical spirit his painting remained full of an unfailing generosity and warmth.

A great painter, a man of faith and of heart, Gromaire is no more. But his work remains and when at last it is seen, known, understood as it must be, we shall discover in it one of the most fruitful messages of today's art.

Jacques Lassaigne

(The quotations by Gromaire are taken from the text he wrote for *Le Point,* December 1954, and published under the title: *En ce siècle déchiré.*)

Blanchard, Maria 1881-1932

Brancusi, Constantin 1876-1957

Brought up in Madrid and studied drawing there. Arrived in Paris 1908, worked with Van Dongen. 1913, returned to teach in Spain until 1916. Back in Paris she met Picasso and the Cubists; formed close friendship with Gris. Her later work was mainly of stylized figure subjects which in her last years took on religious overtones.

1 Still Life with Newspapers, 1919
oil on canvas, 16 x 24 cms
Bequest of Dr Girardin

Born in Rumania. Arrived in Paris in 1904 via Cracow, Bucharest and Munich. After a brief period as Rodin's assistant, began to search for simple primal forms in his sculpture, his bronze heads smooth and egg-like, his wood carvings primitive and rustic.

2 Head of a Woman, c1918
coloured crayon on paper, 44 x 32 cms
Henry/Thomas Donation

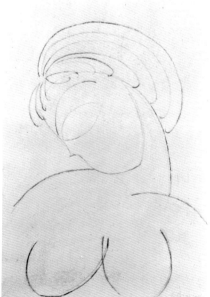

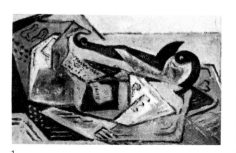

1

2

Braque, Georges 1882-1963

Trained as a decorator in Le Havre. Came to Paris in 1900 and studied as a painter. First essays in Fauvism at Antwerp with Friesz in 1906, developing his most intense use of colour in L'Estaque that autumn. Met Picasso in the autumn of 1907 and next year painted his first Cubist landscapes. Close co-operation with Picasso until 1912. Severely wounded in the war, discharged in 1917.

3 The Olive Tree near to L'Estaque, 1906
oil on canvas, 50 x 61 cms
Henry/Thomas Donation

4 Still Life with Sonata, 1920
oil on canvas, 36 x 65 cms

Chagall, Marc *born* 1889

Spent his childhood in Vitebsk: studied painting in St Petersburg and came to Paris in 1910, forming friendships with Apollinaire, Blaise Cendrars and Max Jacob; became acquainted with Delaunay as well as other immigrant artists. Caught in Berlin at the outbreak of war, he returned to Russia and with the revolution founded an arts school in Vitebsk. After work with the Yiddish Theatre in Moscow he returned to Paris in 1923 to carry out an illustration commission from Vollard.

5 The Dream, 1927
oil on canvas, 81 x 100 cms
Gift of Emanuele Sarmiento

Delaunay, Robert 1885-1941

Early work influenced by the Pont-Aven School and the colour divisionism of Neo-Impressionism. Used to meet Picasso at the Douanier Rousseau's. Adapted Cubism to "Orphism", a term coined by his friend Apollinaire. His work was championed by Blaise Cendrars as well as by Paul Klee and the Blaue Reiter group. He wrote to Kandinsky of "the search for pure painting". Saw the "simultaneous contrast" of colour as "the strongest means of expressing reality."
War years spent in Iberia.

6 Landscape with Cows, c1906
oil on canvas, 50 x 61 cms
Henry/Thomas Donation

7 Nude at the Dressing-Table *or* The Reader, 1915
oil on canvas, 140 x 142 cms
Bequest of Dr Girardin

8 The Eiffel Tower, 1924-26
oil on canvas, 170 x 104 cms
Henry/Thomas Donation

Derain, André 1880-1954

Dufy, Raoul 1877-1953

Ernst, Max 1891-1976

Met Matisse at Académie Carrière and, in 1900, Vlaminck with whom he shared a studio at his native Chatou outside Paris. Summer 1905 with Matisse at Collioure. 1907-8 turned from Fauvism to a structural style influenced by Cézanne and Picasso. Painted with Picasso in Spain 1910.

9 The Lighthouse at Collioure, 1905
oil on canvas, 32 x 40 cms
Henry/Thomas Donation

10 Bathers, c1908
oil on canvas, 38 x 46 cms
Donation of Madame Amos

11 Still Life on a Table, 1910
oil on canvas, 98 x 71 cms
Bequest of Dr Girardin

12 Portrait of a Woman, c1928
oil on canvas, 58 x 42 cms
Donation of Madame Amos

Studied painting with Friesz in Le Havre and from 1900 at the Ecole des Beaux-Arts in Paris. Did not show with Fauves at 1905 Salon d'Automne. 1906 summer with Marquet on Normandy and Brittany coast. With Braque at L'Estaque in 1908, painted Cubist landscapes but returned to a freer style. Encouraged by Poiret to design textiles. In 1937 he executed a vast mural for the Palais de l'Electricité at the World Fair, which now forms a central feature of the Musée d'Art Moderne de la Ville de Paris.

13 Children's Games c1906
watercolour on paper, 33 x 44 cms
Henry/Thomas Donation

14 Landscape in Southern France with Barbary Fig Tree, c1920
oil on canvas, 46 x 55 cms
Henry/Thomas Donation

15 In the Bois de Boulogne, 1920
oil on canvas, 46 x 55 cms
Henry/Thomas Donation

Born in the Rhineland. Self-taught painter after art-history training. 1913 first stay in Paris. 1914-18 army service. 1919 with Arp and others formed Dada group in Cologne. In Paris 1922 onwards, showed at first Surrealist exhibition in Paris 1925. Produced his *Histoire Naturelle* in 1926 using his technique of *frottage,* involving rubbings from natural materials.

16 Flowers, c1925-27
oil on canvas, 65 x 81 cms
Bequest of Robert Azaria

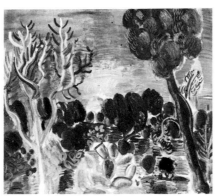

14

Friesz, Emile-Othon 1879-1949

Studied painting in Le Havre with Dufy, and in Paris under Bonnat at the Ecole des Beaux-Arts. First shown at the Indépendants with Dufy in 1903. With Braque in Antwerp 1906 summer and again at La Ciotat in the south in 1907. By 1908 he was painting idyllic, if still vigorous, landscapes peopled by classical nudes.

17 Autumn at Honfleur, 1906
oil on canvas, 64 x 80 cms
Henry/Thomas Donation

Gleizes, Albert 1881-1953

Influenced by Cubism from 1910, he became one of its main theorists and organisers. His Courbevoie studio became a regular meeting-place. In 1912 he was a founder-member of the Section d'Or, helping to organise its first exhibition, and that year wrote with Metzinger *Du Cubisme*.

18 The Clowns, 1917
oil on wood, 103 x 76 cms

Gris, Juan 1887-1927

Came to Paris from Madrid in 1906, moving into the Bateau-Lavoir and forming a friendship with Picasso. He contributed drawings to periodicals but only began seriously to paint in 1910/11, though he exhibited at the Section d'Or in 1912. Like Picasso, continued to work throughout the war. He introduced a classical geometrical order into Cubism which was to be the starting point for Ozenfant and Jeanneret.

19 The Book, 1913
oil on paper mounted on canvas, 41 x 34 cms
Henry/Thomas Donation

Gromaire, Marcel 1892-1971
All these paintings are from the Bequest of Dr Girardin

A self-taught painter. After the war in which he was wounded he developed, under Léger's influence, his style of massive forms applied to subjects of everyday life, transformed in some pictures to heroic proportions. During the thirties he did much to develop modern tapestry work.

20 Begging Musicians, 1919
oil on canvas, 85 x 125 cms

21 Self-Portrait, 1921
oil on canvas, 55 x 46 cms

22 A Station, 1922
oil on canvas, 95 x 120 cms

23 The Gate, 1923
oil on canvas, 46 x 56 cms

24 Portrait of Dr Girardin, 1925
oil on canvas, 100 x 81 cms

25 The Flooded Land, 1926
oil on wood, 32 x 41 cms

26 Two Figures on the Beach, 1927
oil on canvas, 55 x 46 cms

27 Games on the Beach, 1927
oil on canvas, 46 x 55 cms

28 Nude with Coat, 1929
oil on canvas, 81 x 65 cms

29 The Wheelbarrow, 1929
oil on canvas, 81 x 65 cms

30 Peasant Woman with Basket, 1930
oil on canvas, 81 x 65 cms

31 The Sheaf, 1930
oil on canvas, 81 x 65 cms

Herbin, Auguste 1882-1960

Came to Paris in 1903 after art school in Lille. From the early influence of Impressionism he moved to the brightly-coloured though tightly-constructed style seen here. High colour was maintained through his Cubist period (member of Section d'Or), after which his work reverted to being representational. From 1926 his work became wholly abstract. Later a member of Abstraction-Création.

32 Landscape near to Cateau-Cambrésis, c1906
oil on canvas, 65 x 81 cms
Henry/Thomas Donation

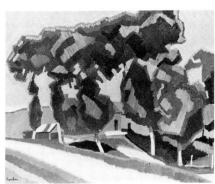
32

La Fresnaye, Roger de 1885-1925

Studied 1903-8 Académies Julian and Ranson. Frequented the meetings at Gleizes's and Villon's studios; founder member of Section d'Or. With paintings like *La Conquête de l'Air* he moved close to Delaunay. After war service he abandoned Cubism for a traditional realistic style.

33 In the Wood, 1910
oil on canvas, 61 x 50
Donation of Madame Amos

34 Still Life with Three Handles, 1910
oil on canvas, 40 x 61 cms
Bequest of Dr Girardin

35 Still Life with Lemons, 1911
oil on card, 24 x 27 cms
Donation Madame Amos

33

Laurencin, Marie 1885-1956

Studied at the Académie Humbert. Contact with the Cubists through her association with Braque and Apollinaire showing with them at the 1911 Salon d'Automne. War years spent in Spain. Theatre work in the twenties and much illustration work. Painted fairy-like pictures of figure groups in clear pastel-like colours.

36 Still Life with Lemons
oil on canvas, 42 x 32 cms

Léger, Fernand 1881-1955

Began as an architectural draughtsman. In Paris from 1900; from 1903 studied at the Ecole des Beaux-Arts. Friendship with Rousseau. Met Delaunay 1907. Shown the work of Picasso and Braque. Joined the Courbevoie meetings and exhibited with the Section d'Or. 1913 abstract *Contrasts of Forms*. Profound experience of war service, sought to apply principles of simultaneous contrasts to subjects of modern life. Contact with De Stijl 1919 and aligned with Purism of Ozenfant and Jeanneret in 1924.

37 Contrasts of Forms, 1918
oil on canvas, 41 x 26 cms

38 Man with a Pipe, 1920
oil on canvas, 91 x 65 cms
Bequest of Dr Girardin

Lhote, André 1885-1962

Studied sculpture at Bordeaux Academy before moving to Paris. From 1911 cautious association with the Cubists and Section d'Or. After the war he founded his own school of painting and active as an author writing regularly for a review.

39 Landscape, Beach through the Trees 1913-14
oil on card, 27 x 47 cms
Donation of Madame Amos

40 Still Life with Coffee Cup
oil on cardboard, 30 x 23 cms

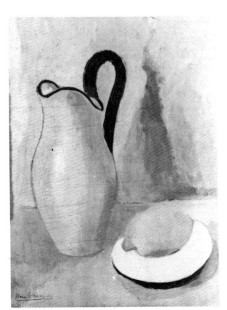

36

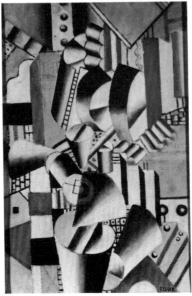

37

39

Lipchitz, Jacques 1891-1973

Born in Lithuania. Arrived in Paris 1909. Studied at the Ecole des Beaux-Arts and Académie Julian. Military service in Russia 1912-13. Returned to Paris 1914, associated with Modigliani and the Cubists, notably Gris whose influence turned him towards Cubism. Already he had come to know the non-naturalistic phases of Egyptian, early Greek, medieval European and African sculpture. In the mid-twenties he abandoned his Cubist style.

41 Seated Figure Playing the Clarinet, 1920
stone, 77 x 40 x 30 cms
Bequest of Dr Girardin

42 Study for Bas-Relief, 1921
oil on wood, 59 x 61 cms
Bequest of Dr Girardin

Manes, Pablo 1891-1963

Brought up in Buenos Aires. Arrived in Paris 1914 becoming a pupil of Bourdelle. Formed a friendship with Juan Gris and was strongly influenced by Lipchitz. After 1926 he occupied a diplomatic post while continuing his career as a sculptor.

43 The Guitarist
Bronze, 39 x 16 x 23 cms

Manguin, Henri-Charles 1874-1943

From 1895 a fellow-student of Matisse in the studio of Gustave Moreau. Exhibited with Matisse and Marquet from 1902. In 1904 shared his studio with Matisse, Marquet and others, painting from the same model. Formed a friendship with Signac and brought his colour experiments to their highest pitch at Saint-Tropez in 1905.

44 Woman Reading with Green Hat, 1909
oil on canvas, 65 x 54
Henry/Thomas Donation

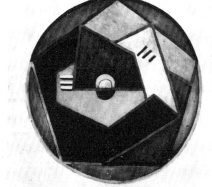

42

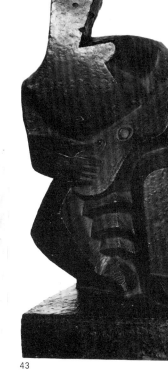

43

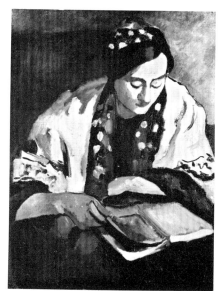

44

Marquet, Albert 1875-1947

Met Matisse at Moreau's school. Influenced by Neo-Impressionism they experimented together with heightened colour 1898-1901. Showed at the Indépendants from 1901. One of the founders of the Salon d'Automne 1903. Maintained close association with Matisse; studios nearby overlooking Notre-Dame. Travelled widely including visit to Morocco with Matisse 1913. Moved to Marseilles 1911.

45 Notre-Dame de Paris under Snow, c1912
oil on canvas, 65 x 81 cms
Bequest of Dr Girardin

Matisse, Henri 1869-1954

Born in northern France. Studied law but began to paint 1890. Studied at Académie Julian, joined Moreau's studio at the Ecole des Beaux-Arts, 1893. 1898 visits to Corsica and Toulouse. Bought one of Cézanne's *Bathers* paintings and Rodin sculpture from Vollard. Began to make sculpture in the 1890s. 1903 co-founder of Salon d'Automne. Association with Signac and central figure of Fauvism. 1904 one-man exhibition at Vollard's. Travels in Spain, Russia, Morocco. 1908 *Notes of a Painter*. Moved from Paris to the South of France.

46 The Model, c1901
oil on canvas, 55 x 38 cms
Bequest of Dr Girardin

47 Woman Lying, 1907
Bronze, 36 x 51 x 27 cms

48 Odalisque with Armchair, 1928
oil on canvas, 60 x 73

Metzinger, Jean 1883-1956

Moved to Paris in 1903; influenced by Neo-Impressionism; close to Fauvism. A co-founder of the Section d'Or and co-author, with Gleizes, of *Du Cubisme*. 1914-15 war service. Adopted a "constructive realist" style.

49 Woman with Lace, 1916
oil on canvas, 65 x 54 cms
Henry/Thomas Donation

50 Allegorical Composition, c1926
oil on canvas, 54 x 73 cms

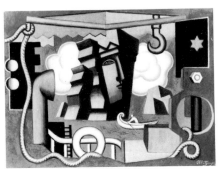
50

Modigliani, Amedeo 1884-1920

Born in Leghorn, studied painting in Florence and Venice. Moved to Paris 1906, first to Montmartre then Montparnasse. Made contact with the group around Picasso. Friendship with Utrillo. In 1909 encouraged by Brancusi to make sculpture, strongly influenced by African art. To Livorno and the Carrara quarries but destroyed sculptures made then. Strongly influenced by Cézanne exhibition at the Bernheim Gallery.

51 Woman with Fan, 1919
(Portrait of Lunia Czekonska)
oil on canvas, 100 x 65
Bequest of Dr Girardin

Ozenfant, Amédée 1886-1968

Began to paint under the influence of Segonzac. In 1915 founded the magazine *L'Elan* criticising the relaxation in the Cubist discipline. Co-author with Jeanneret (Le Corbusier) of *Après le Cubisme* and founded *L'Esprit Nouveau* the magazine of the Purist movement.

52 Still Life with Violin, c1922
oil on canvas, 101 x 81 cms

Pascin, Jules 1885-1930

Born in Bulgaria, father a Spanish Jew. Studied in Vienna. In Munich contributed drawings to the review *Simplicissimus*. Moved to Paris in 1905. Extensive travels in North and South America. In the late twenties most paintings were female nudes or semi-nudes.

53 Marcelle, c1927
oil on canvas, 92 x 65 cms
Gift of Lucy Krohg

54 Venus, Nude from the Back, 1929
oil on canvas, 81 x 65 cms
Gift of Hermine David

Picabia, Francis 1878-1953

Picasso, Pablo 1881-1973

Reth, Alfred 1884-1966

Studied at Atelier Cormon 1909. Connected with Cubism. Took part in discussions at Villon's studio; co-founder of Section d'Or. Visits to USA—contact with Stieglitz. Collaborated with Duchamp. 1918 associated with Dada group in Zurich. 1919 moved back to Paris. From 1924 active contact with Surrealists.

55 Optophone II, 1922-24
oil on canvas, 116 x 88 cms
Henry/Thomas Donation

Born in Malaga, studied in Barcelona. 1900-1904 between Paris and Spain. 1904 settled in Paris at Bateau-Lavoir. 1907 *Les Demoiselles d'Avignon,* 1907-12 close relationship with Braque. 1912 moved to Montparnasse; first *papier collés*. Worked throughout war. Early 1920s neo-classical figure paintings alternating with continuation of synthetic Cubism.

56 The Frugal Meal, 1904
etching, 46 x 46 cms

57 Head of a Woman, 1905
bronze, 35 x 24 x 22 cms
Gift of Ambroise Vollard

58 The Pigeon with Peas, 1911
oil on canvas, 64 x 53 cms
Bequest of Dr Girardin

59 Composition, 1923
gouache on card, 27 x 20 cms

Born in Budapest. He arrived in Paris in 1905, via Italy, and studied at the Académie Jacques-Emile Blanche, living in Montparnasse. From 1908 he studied Hindu art and while developing a Cubist style he tried to introduce mystic principles into his work, coming close to abstraction 1909-11. After the war his work returned to a more realistic and less intellectual mode.

60 Composition, 1913
oil on canvas, 50 x 65 cms
Henry/Thomas Donation

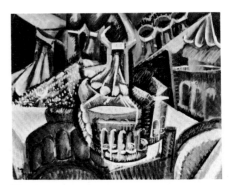

60

Rouault, Georges 1871-1958

Apprenticed as stained-glass painter. Studied with Gustave Moreau from 1892. Became curator of Moreau museum, 1903. Co-founder of Salon d'Automne. 1902 began to work in watercolour and gouache on paper, predominantly in blue. His paintings of prostitutes, perhaps influenced by Daumier, Lautrec, Forain, were one of the shocks of the 1905 Salon d'Automne. 1906 onwards in ceramics. 1914-27 work on graphic series *Misereré*; 1918-19 *Reincarnations du Père Ubu,* both for Vollard. 1918 reverted to oils. Later paintings exclusively religious.

61 Circus, 1905
(Pierrot, Punch and Harlequin)
watercolour and pastel on paper, 32 x 24 cms
Bequest of Dr Girardin

62 Nude from the Back, c1906
oil thinned with spirit on paper, 31 x 25 cms
Bequest of Dr Girardin

63 Girl *or* Nude with Red Garters, 1906
watercolour and pastel on paper, 71 x 55 cms
Bequest of Dr Girardin

64 Nude with Arms Raised, Arranging her Hair, 1907
watercolour and pastel on paper, 30 x 30 cms
Bequest of Dr Girardin

65 Winter, 1910
Pastel and ink on paper, 19 x 31 cms
Bequest of Dr Girardin

66 Pedagogue, 1912
crayon and gouache on paper, 15 x 20 cms
Bequest of Dr Girardin

67 Judges in front of a Crucifix, c1913
crayon, ink and watercolour on paper, 30 x 19 cms
Bequest of Dr Girardin

68 Parisian Suburb (banks of the Seine), c1914
ink and coloured chalk on paper, 20 x 31 cms
Bequest of Dr Girardin

69 Lackey, 1917
watercolour and crayon on paper, 30 x 19 cms
Bequest of Dr Girardin

Soutine, Chaim 1894-1943

Born near Minsk; 1913 moved to Paris; took studio in La Ruche with Chagall. Met Modigliani through Lipchitz. Early enthusiasm for Tintoretto and El Greco, later for Rembrandt. 1919-22 in Céret in Pyrenees (where Picasso and Braque had earlier painted) producing violently writhing landscapes.

70 Woman in Blue Dress, c1922
oil on canvas, 31 x 60 cms

65

67

Survage, Léopold 1879-1968

Studied in Moscow. Arrived in Paris 1908 and studied briefly under Matisse. Exhibited in the Cubist room of the 1911 Salon des Indépendants. During the war he painted townscapes in the south of France in which he introduced collage-like realistic elements associated with the scene. Of these Apollinaire wrote: "No one before him was able to include in a single picture a whole town with the interiors of its houses." In 1919 he associated with Gleizes and Metzinger in the revival of the Salon de la Section d'Or.

71 Landscape, 1915
oil on canvas, 60 x 81 cms

Utrillo, Maurice 1883-1955

Illegitimate son of Suzanne Valadon. No formal training. Began painting in 1902. Influenced by Pissarro. Exhibited first at the Indépendants 1912, towards the end of his "white period" in which his palette was tightly restricted. Colours became stronger in the 1920s, often painting from postcards.

72 La Fère en Tardenois, 1912
oil on canvas, 81 x 60 cms
Bequest of Dr Girardin

73 The House of Berlioz, 1914
oil on canvas, 46 x 73 cms
Bequest of Dr Girardin

Valadon, Suzanne 1867-1938

Came to Paris as a child. Lived in Montmartre in her youth; circus performer but injured. Became model for Puvis de Chavannes, Renoir and Degas. Began to paint. Later association with Max Jacob, Apollinaire, Derain and influenced by Matisse. Developed a decorative style characterized by heavy outlines.

74 Portrait of Utrillo at his Easel, 1919
oil on card, 48 x 45 cms
Bequest of Dr Girardin

75 Nude with Striped Coverlet, 1922
oil on canvas, 104 x 79 cms

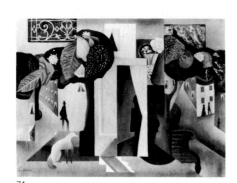

71

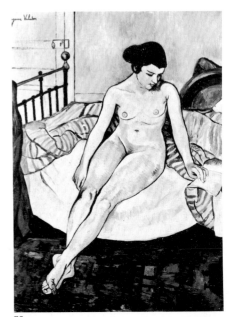

75

Valmier, Georges 1885-1937 Valtat, Louis 1869-1952 Van Dongen, Kees 1877-1968

Studied at the Ecole des Beaux-Arts in Paris 1905-9. Adopted a Cubist style in 1911. After war service he developed a colourful synthetic Cubism, frequently involving collage, which finally became wholly abstract.

76 Composition, 1922
oil on canvas, 90 x 65 cms
Henry/Thomas Donation

An exact contemporary of Matisse. Studied at the Académie Julian; knew Bonnard, Vuillard. Then brief period at the Atelier Gustave Moreau. Never a member of the Fauvist group but associated with them at the 1905 Salon d'Automne with one of his marine paintings reproduced in *L'Illustration* alongside the Fauves. 1913, moved to Paris, visits to Brittany, Normandy.

77 Children Playing in the Rue Caulaincourt,
oil on canvas, 38 x 46.cms
Henry/Thomas Donation

Born near Rotterdam. Came to Paris 1897. Friendship with Signac; neo-Impressionist phase. 1904 first one-man show at Vollard's and first showed at the Indépendants. Developed a mixed technique and intensely coloured Fauvism; friendship with Vlaminck. Moved away from normal Fauve subject matter, painting his friends and Montmartre night-life. 1906-7 lived in the Bateau-Lavoir. Became predominantly a painter of fashionably-dressed women.

78 Two Women, C1910
oil on canvas, 100 x 73 cms
Donation of Madame Amos

79 Woman with Red Hat, C1920
oil on canvas, 64 x 45 cms
Donation of Madame Amos

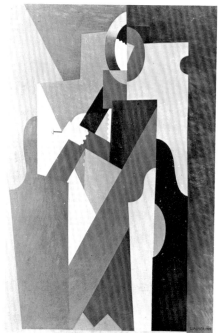

76

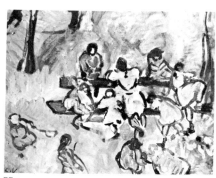

77

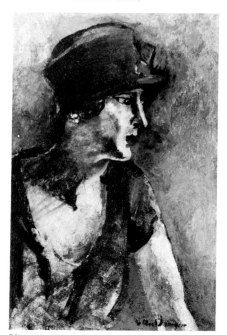

79

Villon, Jacques 1875-1963

Real name Duchamp but adopted name of his favourite poet. Brother of Marcel Duchamp and Raymond Duchamp-Villon. Began to study law. 1894 to Paris with Raymond. Studied at the Ecole des Beaux-Arts in the Atelier Cormon. Made cartoons and posters for the cabarets, influenced by Degas and Lautrec. Founder member of Salon d'Automne 1903. Reacted against static nature of Cubism. His Puteaux studio became a meeting place for Kupka, Gleizes, Metzinger, Picabia, Léger, La Fresnaye and others; formation of Section d'Or with Gris, Lhote, Delaunay, Marcoussis. 1914-16 war service.

80 Seated Woman, seen from the Back, 1944
oil on canvas, 81 x 65 cms
Bequest of Dr Girardin

Vlaminck, Maurice de 1876-1958

Began as a racing cyclist. Self-taught painter. Met Derain 1900 and shared a studio with him at Chatou. Influenced by 1901 van Gogh exhibition but more significantly by the 1905 exhibition. 1906, Vollard bought contents of his studio as he had with Derain, 1905. The most overtly expressionist of the Fauves: "I want to reveal myself to the full, with my qualities and my defects." Retreated from Fauvism to Cézannesque landscapes.

81 Forest, c1910
oil on canvas, 59.5 x 75 cms
Bequest of Dr Girardin

Zadkine, Ossip 1890-1967

At 16 came to England from Russia. Took art classes in Sunderland, moved to London in 1907, forming friendships with David Bomberg and William Rothenstein. Studied the Elgin marbles and Chinese wood sculptures in the British Museum. In 1909 he moved to Paris, studied briefly at the Ecole des Beaux-Arts and came to know Archipenko, Lipchitz and Brancusi. Influenced to an extent by Cubism, but more by African art and French Romanesque sculpture.

82 Young Woman Playing the Mandolin, c1918-20
Bequest of Dr Girardin

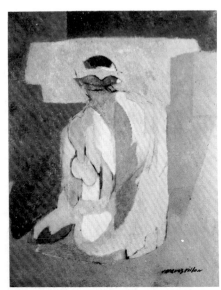

80